ALL THE
REASONS
I LOVE YOU

ICE HOUSE BOOKS

 Published by Ice House Books

Copyright ©2020 PABUKU.
Licensed by This is Iris. www.thisisiris.co.uk

Words by Pabuku & Samantha Rigby

Ice House Books is an imprint of Half Moon Bay Limited
The Ice House, 124 Walcot Street, Bath, BA1 5BG
www.icehousebooks.co.uk

ISBN 978-1-913308-00-1

Printed in China

TO

..

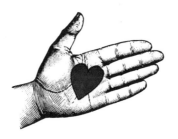

FROM

..

YOU GIVE
ME THE
BALLS
TO BE
STRONG.

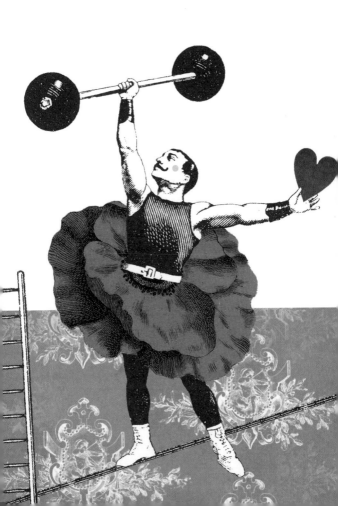

YOU HELP ME
TO SEE
THE WORLD
DIFFERENTLY.

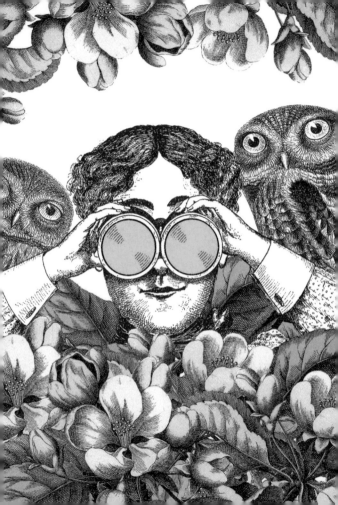

YOU LET ME BE ME.

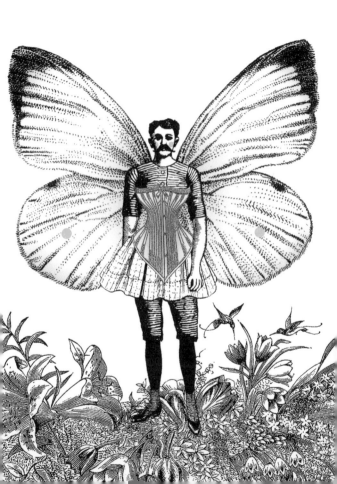

YOU'RE THE
RAINBOW
WHEN IT RAINS.

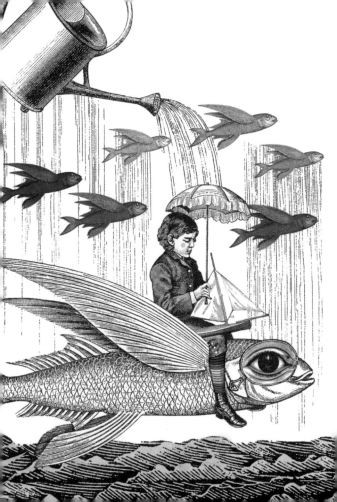

WITH YOU,
I BELIEVE
I CAN BE
ANYTHING
I WANT TO BE.

YOU KEEP OUR
LITTLE BOAT
STEADY.

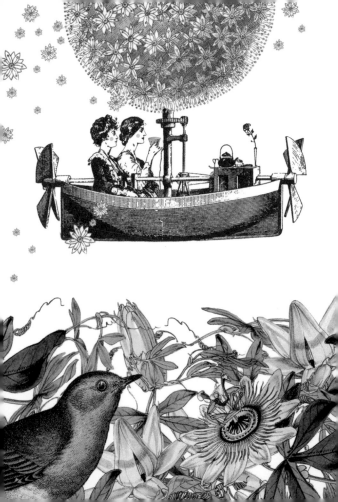

YOU ADD
A LITTLE COLOUR
TO MY
UPSIDE-DOWN
DAYS.

YOU'RE MY
MEDICINE.

YOU KNOW HOW
TO LOOK AFTER
MY HEART.

WHEREVER WE GO,
OUR STORY WILL
ALWAYS
START AND END
WITH LOVE.

YOU MAKE ME
FEEL LIKE
ROYALTY,
EVERY DAY.

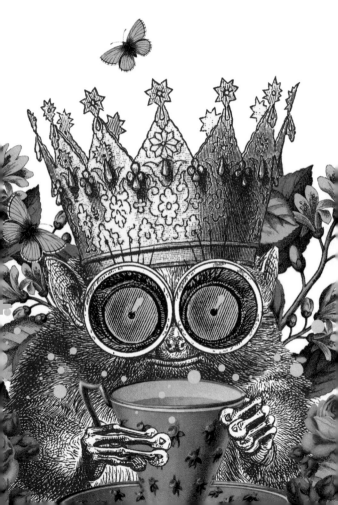

YOU'RE MY
VERY OWN
CHEERLEADING
SQUAD.

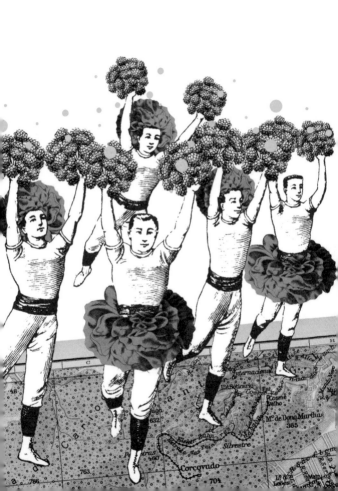

YOU EMBRACE
MY FESTIVE
NATURE
(EVEN IN
SEPTEMBER).

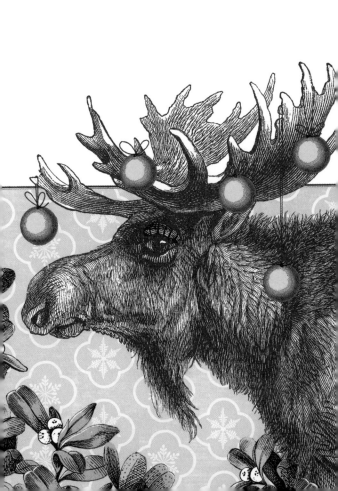

YOU'RE SO
HANDSOME.

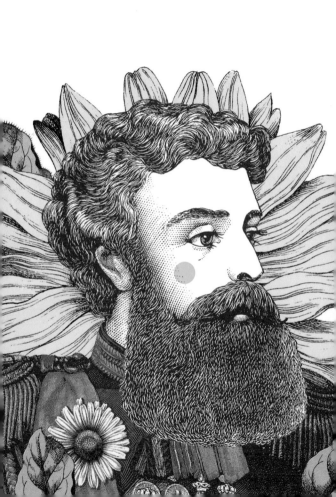

WITH YOU,
I'M ALWAYS
HOME.

YOU BRING
ME FLOWERS,
SOMETIMES.

YOU KEEP ME
AFLOAT.

I FEEL
LIKE DOING
CARTWHEELS
WHEN YOU'RE
AROUND.

YOU FIX
THINGS.

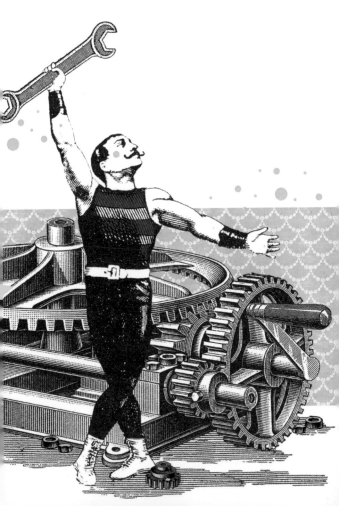

YOU'RE MY
SUPERHERO.

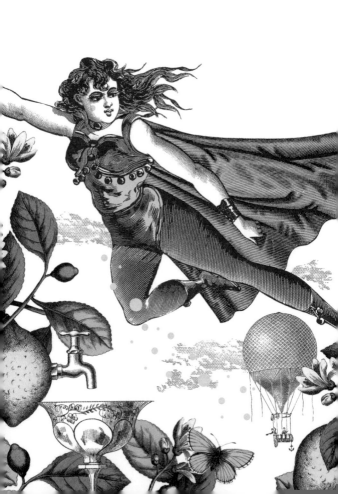

YOU'RE THE ONLY FISH IN MY SEA.

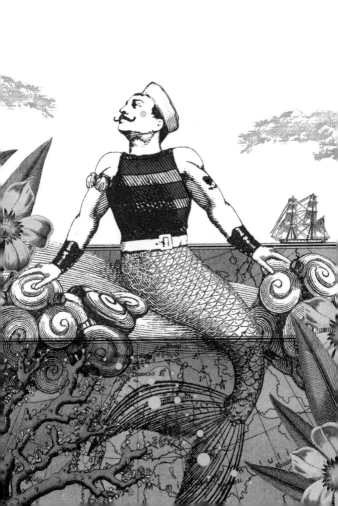

YOU'VE GOT
GREAT HANDS.

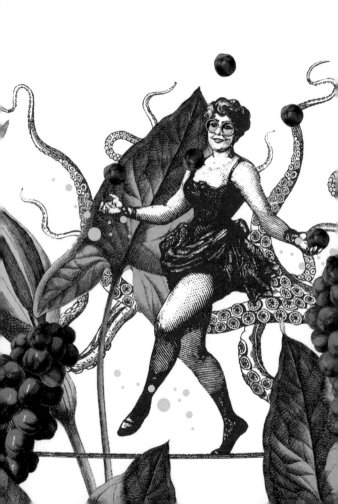

YOU MAKE ME
FEEL LIKE
DANCING.

I'VE FALLEN
IN LOVE MANY
TIMES, BUT
ALWAYS WITH
YOU.

WHEN I HOLD YOU IN MY ARMS, I FEEL LIKE I'M HOLDING THE WHOLE WORLD.

YOU UNDERSTAND
I NEED TO
MAKE TIME
FOR MYSELF.

YOU GIVE
ME WINGS,
SO I CAN
FLY.

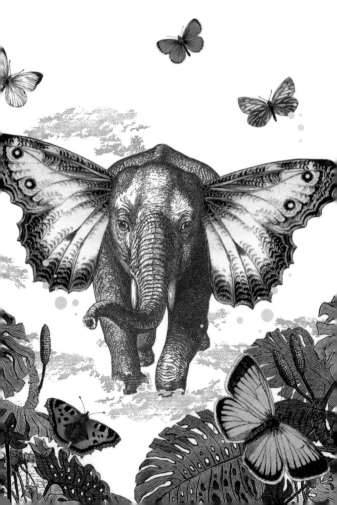

MAGIC HAPPENS WHEN WE'RE TOGETHER.

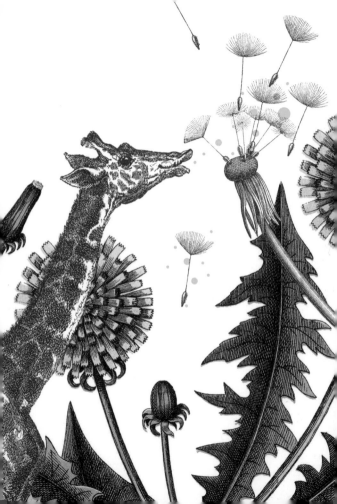

WE GROW
TOGETHER.

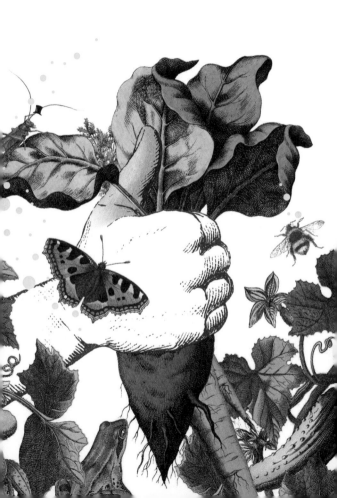

LOVE IS
KNITTED INTO
OUR FABRIC.

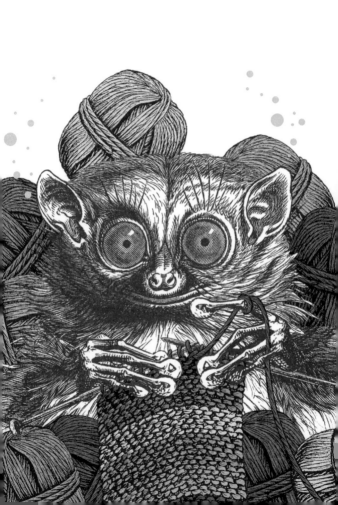

YOU ARE MY KING.

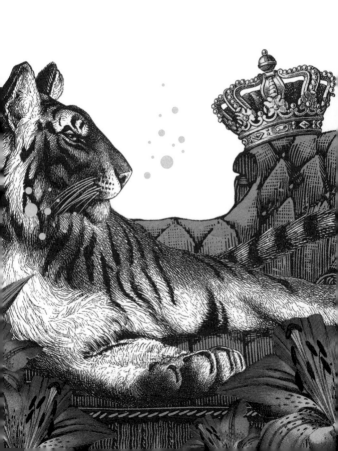

YOU FILL
EVERY DAY
WITH
MUSIC.

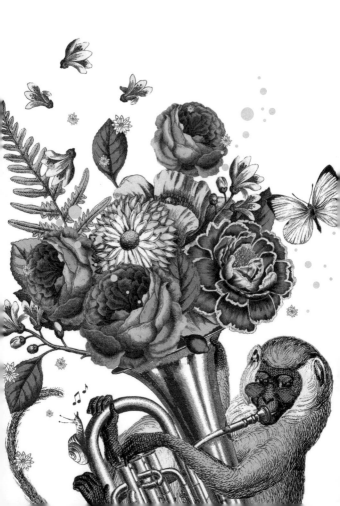

YOU KNOW
WHEN
I NEED
COFFEE.

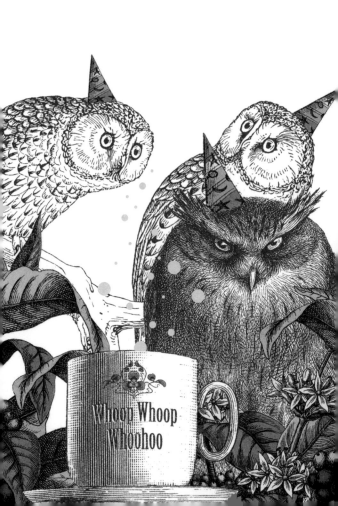

EVERY DAY
WITH YOU
IS A DAY TO
CELEBRATE.

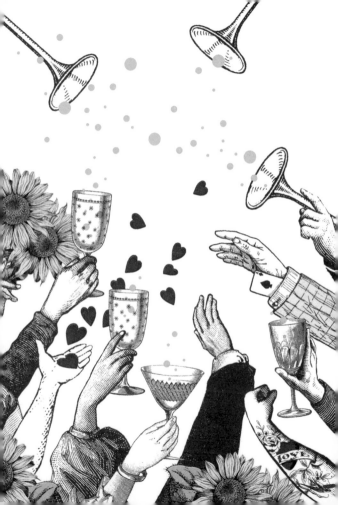

I'M PROUDLY
PUNCHING
ABOVE
MY WEIGHT.

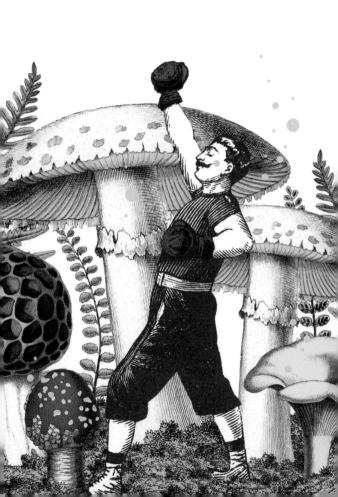

EVEN WHEN
I'M ALONE,
I'M AT PEACE
BECAUSE
YOU EXIST.

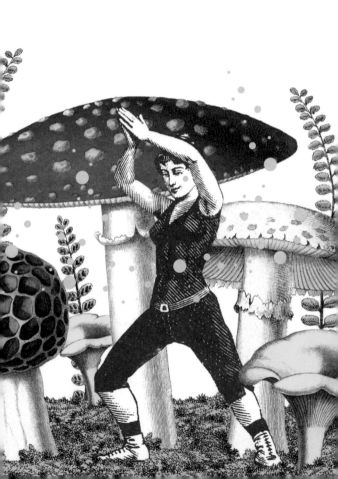

YOU LOVE ME
FOR MY
WEIRDNESS.

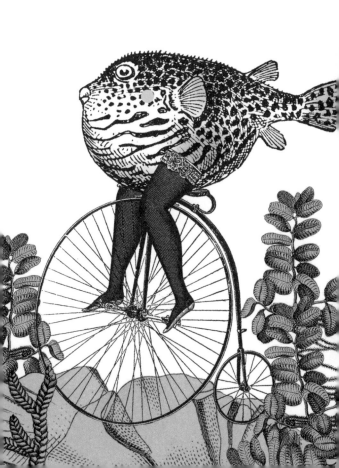

WE DON'T PUT
EACH OTHER
IN CAGES.

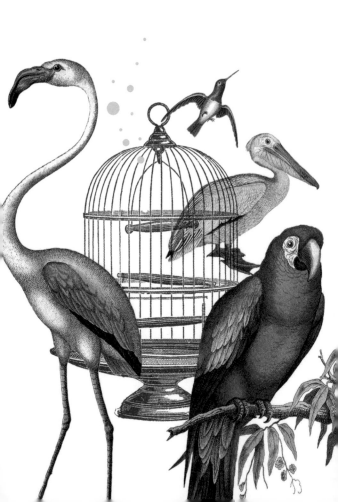

YOU SPREAD
MAGIC
WHEREVER
YOU GO.

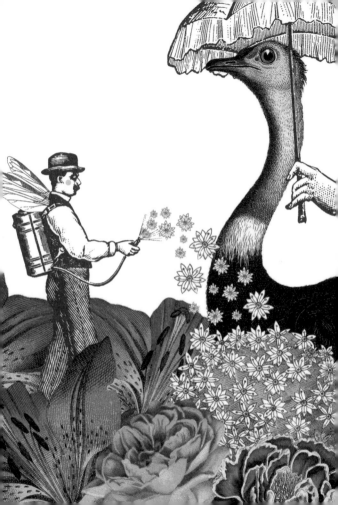

TOGETHER,
WE ALWAYS
FIND A WAY.

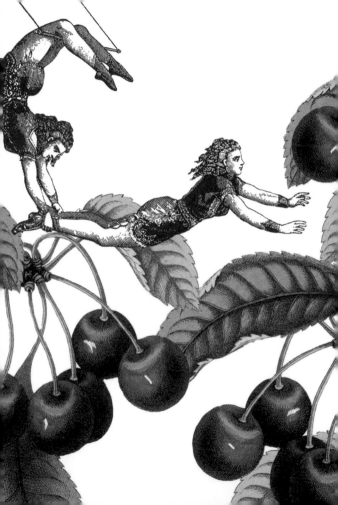

WE BOTH PULL OUR WEIGHT.

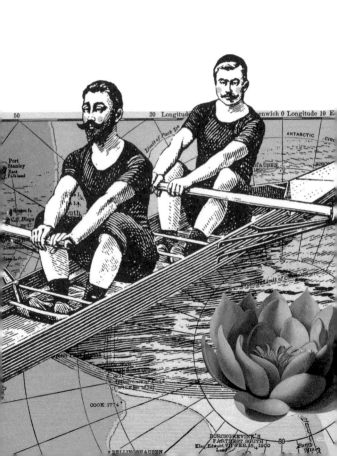

YOU ARE
THE
ONE.

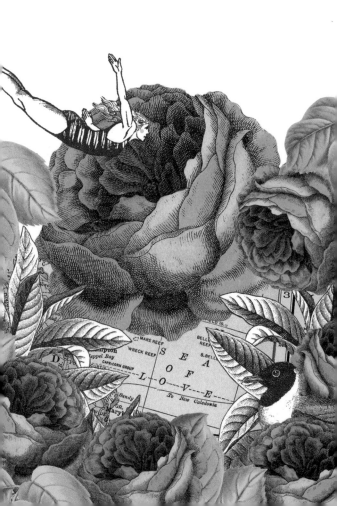

YOU GIVE
THE
BEST HUGS.

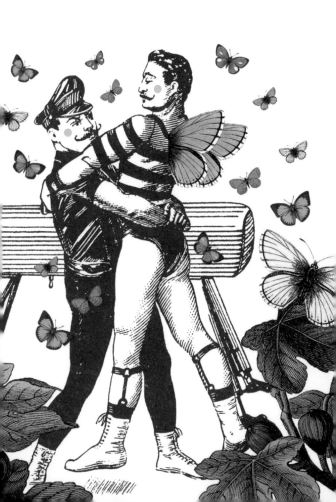

YOU GIVE
ME ALL
THE COLOURS
TO MAKE
ART.

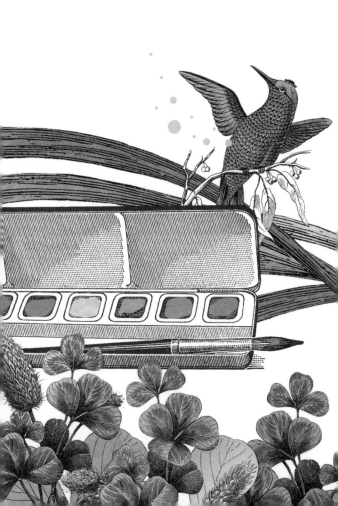

IT TAKES
TWO
TO TANDEM,
AND YOU'RE
THE
PERFECT
PARTNER.

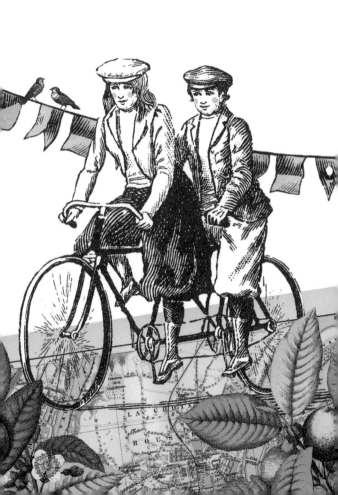

YOU SOW SEEDS
TO MAKE US
A BEAUTIFUL
GARDEN.

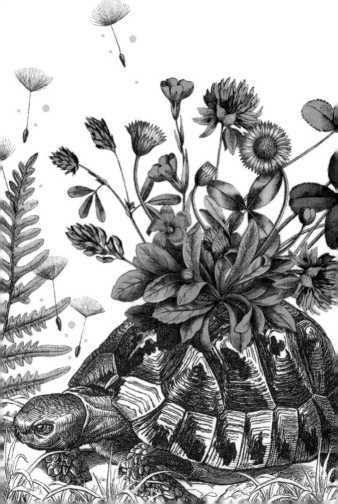

I WANT TO
LIVE LONG
AND
PEACEFULLY
WITH YOU.

YOU'RE THE
GOLD
AT THE END
OF THE
RAINBOW.

YOU
LIFT ME UP
WHEN I NEED
IT MOST.

YOU KISS ME,
EVEN WHEN I'M
FEELING MORE
FROG THAN
PRINCESS.

YOU LOVE MY
WEIRD
FRIENDS,
AND I
LOVE YOURS.

TOGETHER, WE CAN GO ANYWHERE.

YOU CONJURE
FABULOUS
THINGS.

IN A WORLD OF FLAMINGOES, YOU'RE MY PENGUIN.

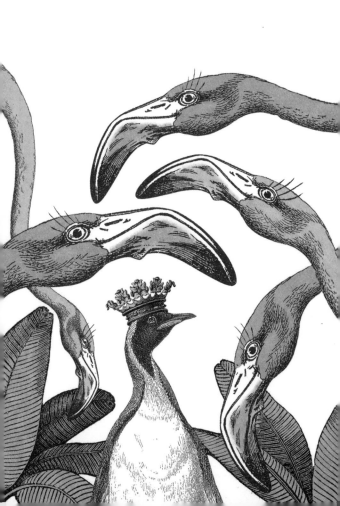

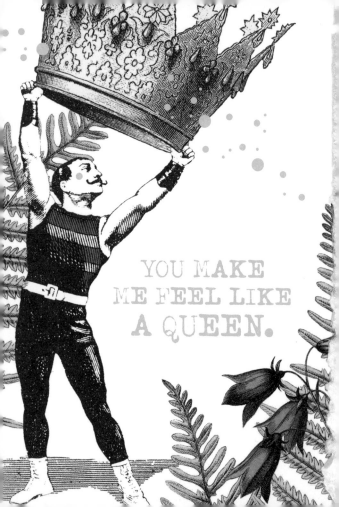

YOU MAKE
ME FEEL LIKE
A QUEEN.